Belle's Wild Ride

The Artful Adventure

of a Butterfly

and a Cabbie

Mary Lee Corlett

To May + Emma ~
Enjoy the Ride!
Mary Lee Corlett
2014

Illustrations by Sophie Cayless

Wishing you your own art adventure!
Sophie Cayless

The Cleveland Museum of Art
in association with
D Giles Limited, London

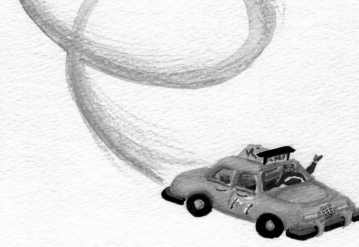

"The artist invites the spectator to take a journey within the realm of the canvas. The spectator must move with the artist's shapes in and out, under and above, diagonally and horizontally; he must curve around spheres, pass through tunnels, glide down inclines, at times perform an aerial feat of flying from point to point, attracted by some irresistible magnet across space, entering into mysterious recesses. . . . Without taking the journey, the spectator has really missed the essential experience of the picture."
—Mark Rothko

The Artist's Reality: Philosophies of Art, edited and with an introduction by Christopher Rothko (New Haven and London: Yale University Press, 2004), 43, 47.

First published in 2014 by GILES
An imprint of D Giles Limited
4 Crescent Stables
139 Upper Richmond Road
London, SW15 2TN, UK
www.gilesltd.com

Library of Congress Control Number: 2014937926

Hardcover ISBN: 978-1-907804-51-9

For the Cleveland Museum of Art:
Edited by Editor-in-Chief Barbara J. Bradley, assisted by Amy Sparks
Photographs are by Chief Photographer Howard Agriesti

For D Giles Limited:
Copy-edited and proof-read by Sarah Kane
Designed by Caroline and Roger Hillier, The Old Chapel Graphic Design
Produced by GILES, an imprint of D Giles Limited, London
Printed and bound in China

All measurements are in centimeters; height precedes width precedes depth.

I am a butterfly who doesn't fly. Usually.
That's because I was painted into **Vase of Flowers** over 300 years ago by the artist
Jan Davidsz de Heem.
My name is Belle and mostly I stay in the exact spot where I was painted. Mostly.
But this is the story of a most unusual day and a most unusual trip.

It all started at the National Gallery of Art in Washington, DC, when my painting and
Wrapping It Up at the Lafayette, a collage painting by Romare Bearden, sat side by side in
the packing room. My painting was headed for a special exhibition in Miami and the Bearden
painting, with my friend Sunny painted on it,
was going back home to Cleveland.

"Cleveland! I am so jealous!" I told Sunny.
"My grandma is there and I haven't
seen her in ages!"

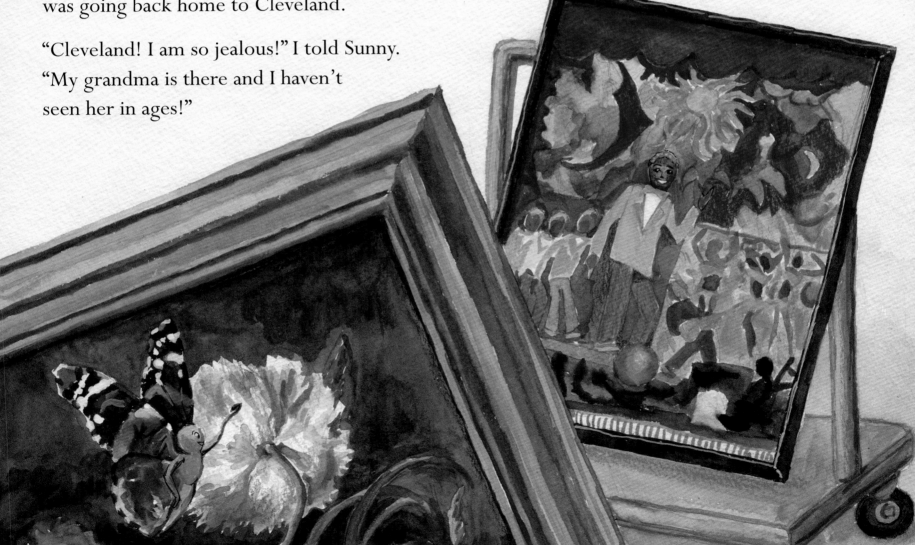

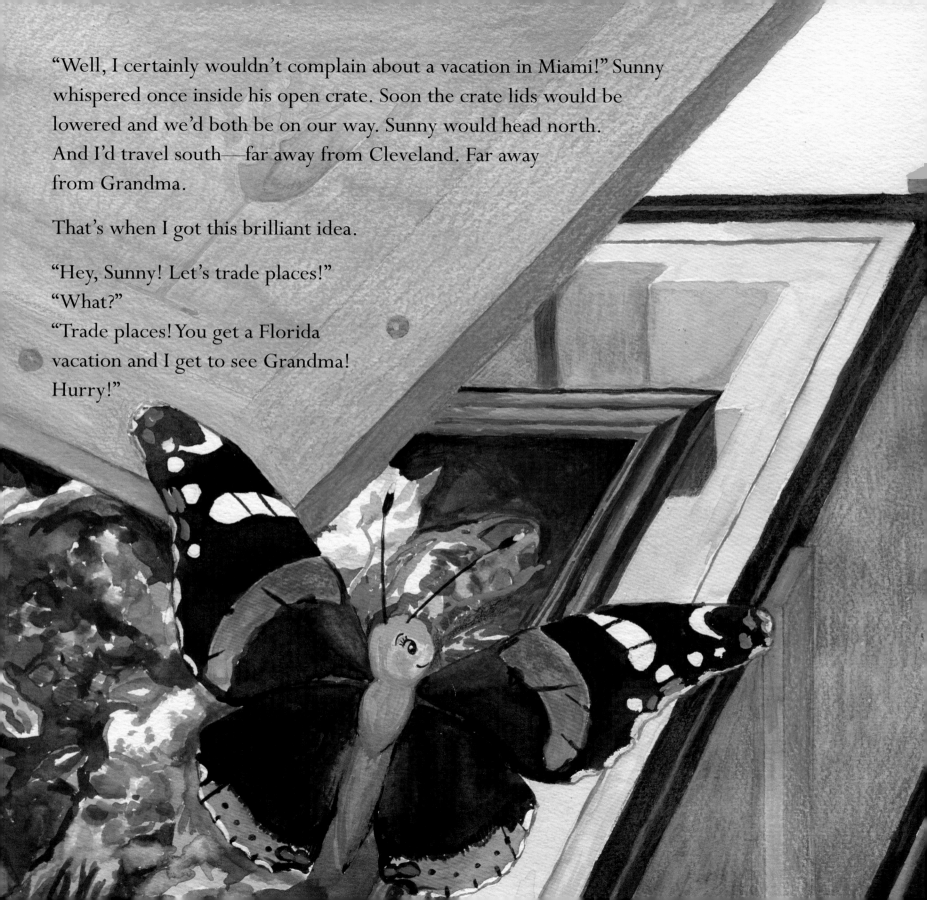

"Well, I certainly wouldn't complain about a vacation in Miami!" Sunny whispered once inside his open crate. Soon the crate lids would be lowered and we'd both be on our way. Sunny would head north. And I'd travel south—far away from Cleveland. Far away from Grandma.

That's when I got this brilliant idea.

"Hey, Sunny! Let's trade places!"
"What?"
"Trade places! You get a Florida vacation and I get to see Grandma! Hurry!"

The art handlers were coming with those crate lids. No time for second thoughts. I hitched a ride on a gentle whoosh of air as my lid came down and Sunny slipped out from under his on the last beam of light.

We flashed past each other and switched places. I awkwardly settled into Sunny's spot on the Bearden.

As the last screw was tightened, sealing the crate, I had to wonder what I'd just gotten myself into!

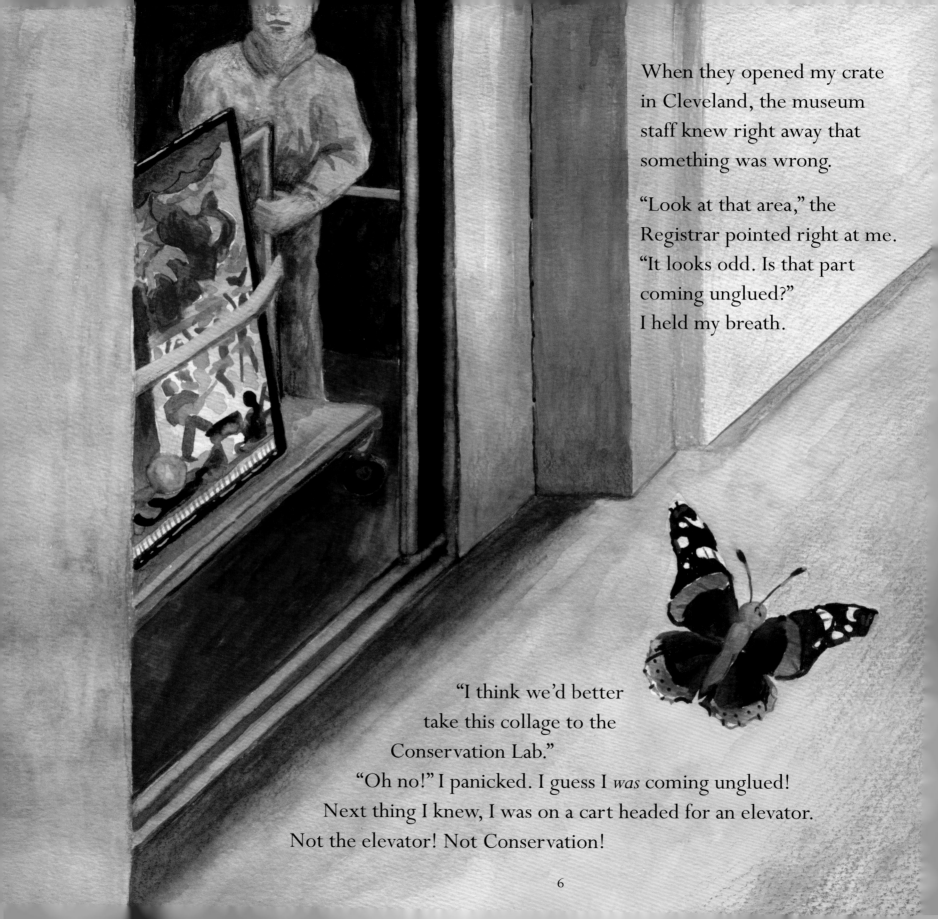

When they opened my crate in Cleveland, the museum staff knew right away that something was wrong.

"Look at that area," the Registrar pointed right at me. "It looks odd. Is that part coming unglued?"
I held my breath.

"I think we'd better take this collage to the Conservation Lab."
"Oh no!" I panicked. I guess I *was* coming unglued!
Next thing I knew, I was on a cart headed for an elevator.
Not the elevator! Not Conservation!

6

Maybe it was the bumps and rumbles
as the cart entered the elevator.
Or maybe it was that whoosh of air
wafting up the elevator shaft.
Or maybe, *maybe* wishing for something
hard enough can make it come true.
WISH!—whoosh—clunk!

When the elevator doors closed, the
Bearden was still inside and I was
outside in the hallway. Free!

A little girl pointed at me, but her mother wasn't paying any attention.
Hiding in plain sight is pretty easy among most humans.

But I had a problem. I didn't know
where to find Grandma. I was
fluttering about aimlessly
when I heard a muffled screech.

"Where're ya headed?" I turned toward the faint sound and saw a yellow cabbie in a case, frantically waving. "Need a ride?"

"Well, yes. OK. I'm not sure exactly where . . . wait, I have an address."

"Typical tourist," he muttered. "So, what is it?"

"I'm going to visit my Grandma Bozeheart. 1606 Oil on Copper. Do you know the location?"

"I know this museum inside and out. Climb in."

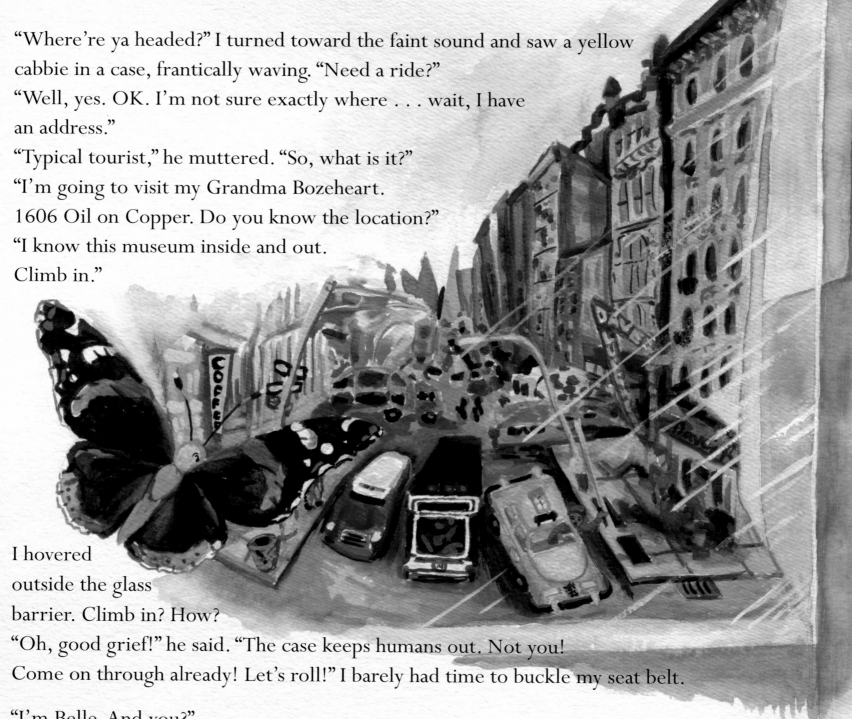

I hovered outside the glass barrier. Climb in? How?

"Oh, good grief!" he said. "The case keeps humans out. Not you! Come on through already! Let's roll!" I barely had time to buckle my seat belt.

"I'm Belle. And you?"

"Red," he answered. End of small talk. The cabbie floored it. There was no use *Looking Along Broadway* —we were moving too fast to see anything. The G-force nearly pulled the color off of my wings. Maybe I should have taken the bus.

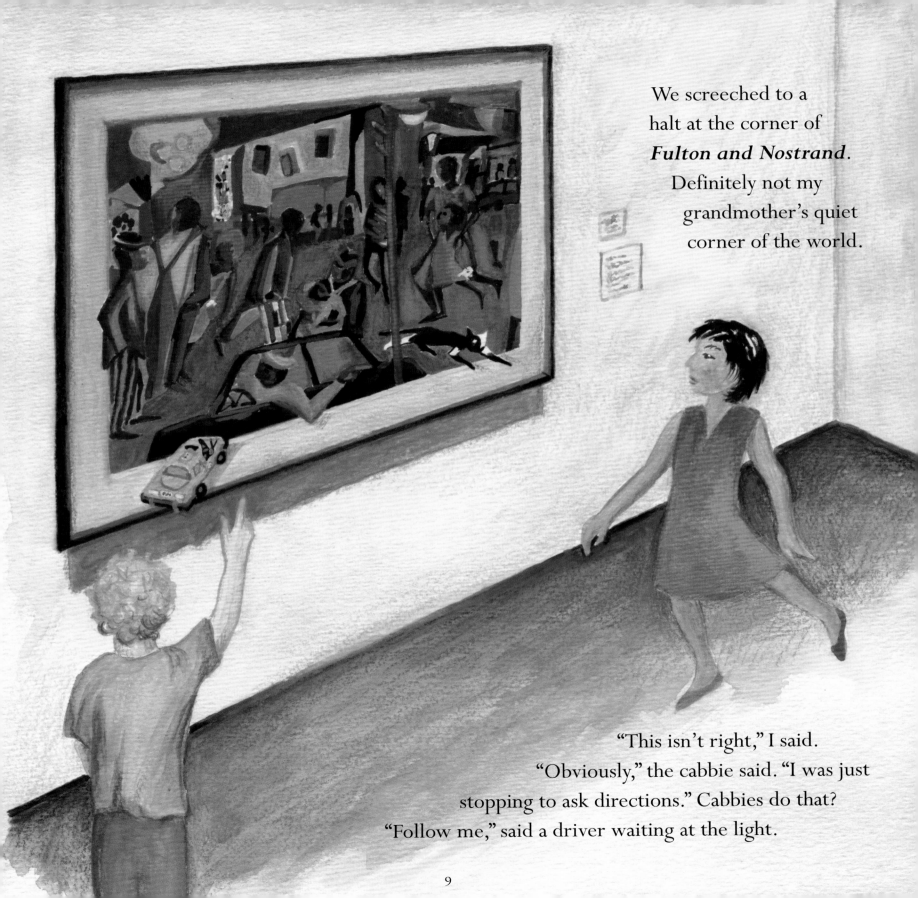

We screeched to a
halt at the corner of
Fulton and Nostrand.
Definitely not my
grandmother's quiet
corner of the world.

"This isn't right," I said.
"Obviously," the cabbie said. "I was just
stopping to ask directions." Cabbies do that?
"Follow me," said a driver waiting at the light.

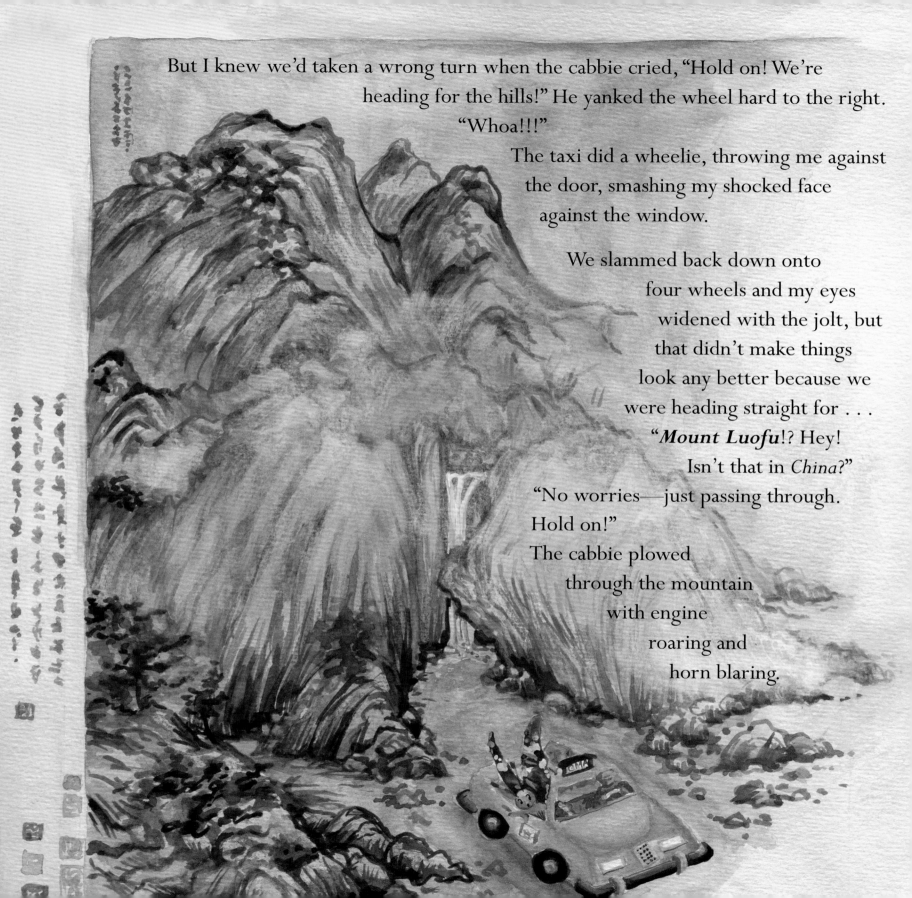

But I knew we'd taken a wrong turn when the cabbie cried, "Hold on! We're heading for the hills!" He yanked the wheel hard to the right. "Whoa!!!"

The taxi did a wheelie, throwing me against the door, smashing my shocked face against the window.

We slammed back down onto four wheels and my eyes widened with the jolt, but that didn't make things look any better because we were heading straight for . . . "***Mount Luofu***!? Hey! Isn't that in *China*?"

"No worries—just passing through. Hold on!" The cabbie plowed through the mountain with engine roaring and horn blaring.

I closed my eyes, knowing I must be headed straight for **Secret Butterfly Heaven**.
We took the high road, then the low road, bumping along the folds.
Riding in this taxi was certainly a new experience. I was made of paint, so I was
used to blending in. But this guy demanded space—and he didn't know the
meaning of "merge."

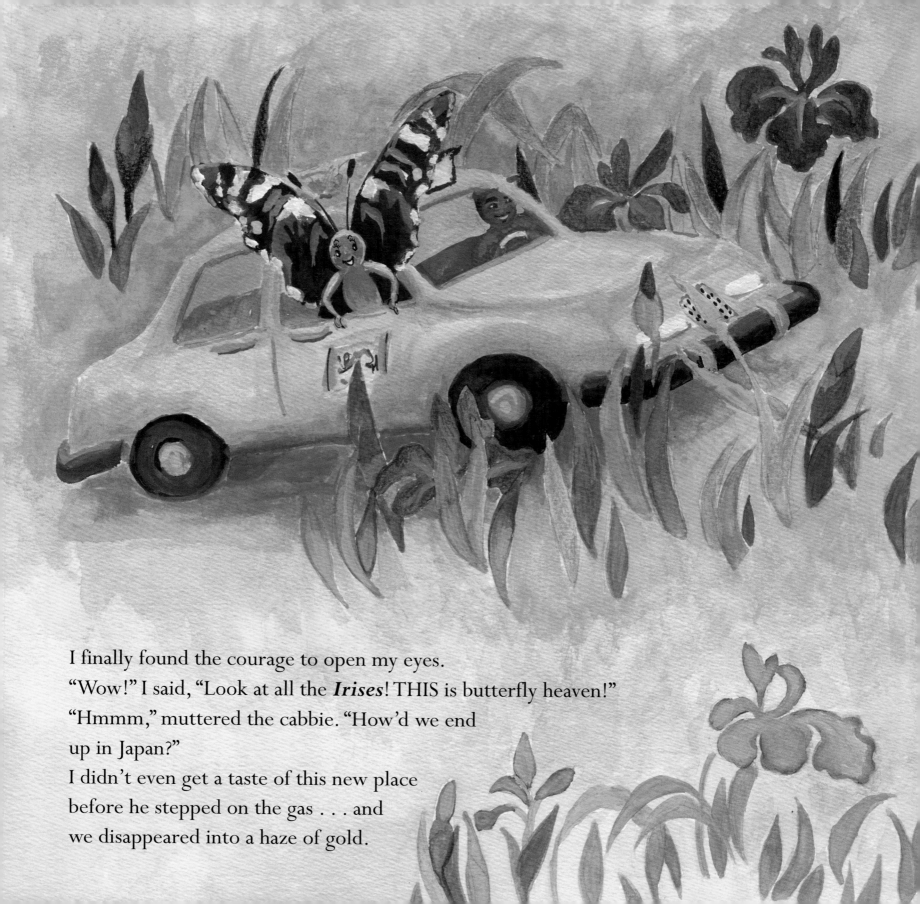

I finally found the courage to open my eyes.
"Wow!" I said, "Look at all the *Irises*! THIS is butterfly heaven!"
"Hmmm," muttered the cabbie. "How'd we end
up in Japan?"
I didn't even get a taste of this new place
before he stepped on the gas . . . and
we disappeared into a haze of gold.

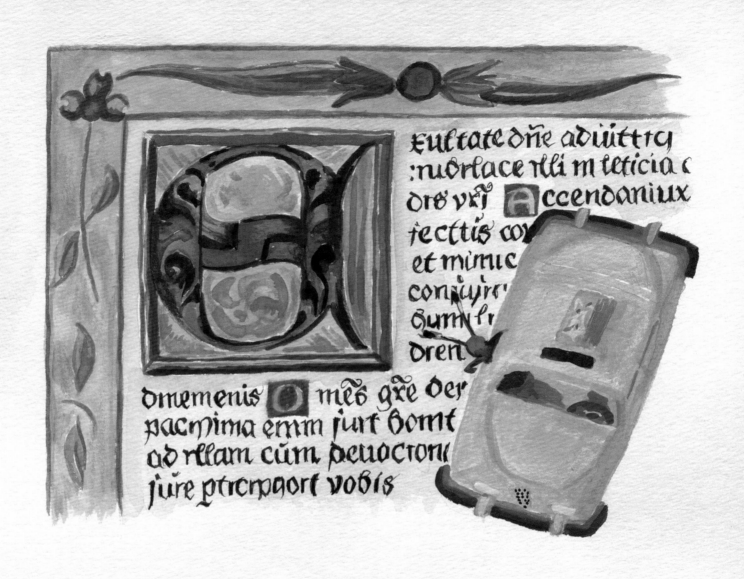

We popped out in . . . "Germany? Hey, maybe we're getting close!
But wait, do I want Antwerp or Amsterdam? Red, I think if we
head due west . . ."
We lurched suddenly and turned sharply onto a new *Leaf*.
"Heading south by southeast!" Red shouted. "Say your prayers!"
I pinched my eyes shut as we crossed the border and plunged
off the edge.

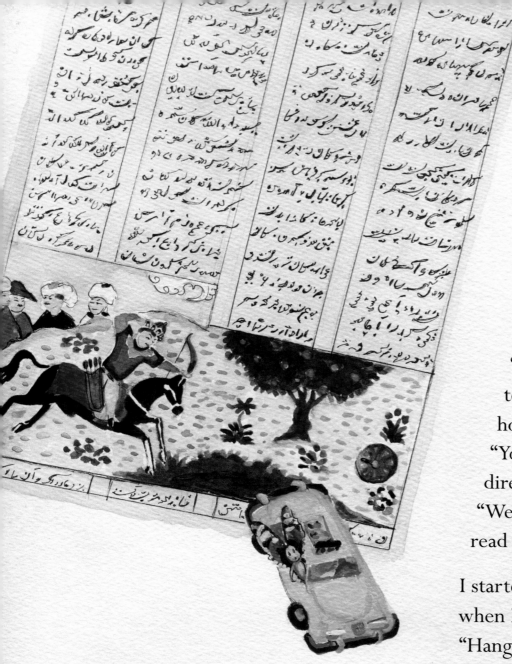

When we surfaced we were surrounded by strange writing. "What does this say?" I asked.

"Shhhh. I'm trying to read." He had the nerve to shush me?

"You don't have any idea how to get me to Grandma's, do you?" I asked.
"It's not that I don't know where to go, it's just that I don't know how to *get* there."
"You need a map! You need directions!"
"Well, *that's* why I am trying to read this!"

I started to study those notations too, when Red began to roll.
"Hang on! We've become a **Rolling Target**! We need more horse power!" he screeched.

In a flash we were near **Hartenfels Castle**.
TALK ABOUT horse power! Hunters on horseback were everywhere, with stags and dogs running amok and arrows whizzing by in every direction.
"Let's get out of here!" I yelled. Red hit the gas and we raced after a knight in shining **Armor**.

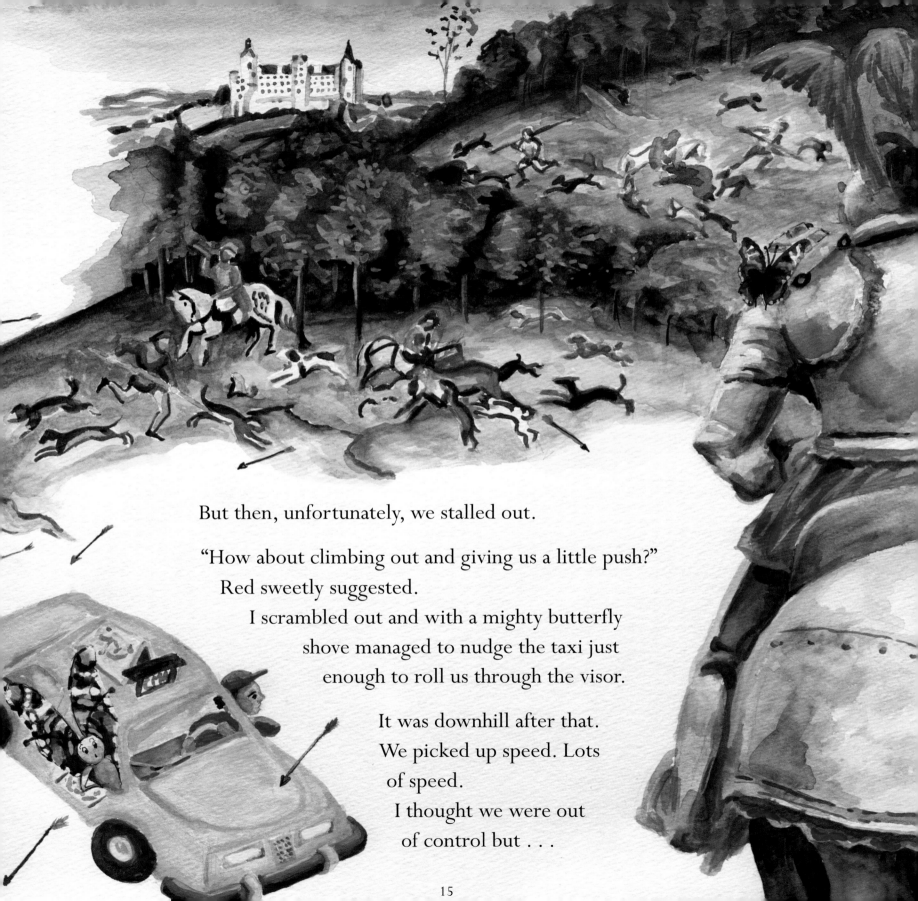

But then, unfortunately, we stalled out.

"How about climbing out and giving us a little push?"
Red sweetly suggested.
I scrambled out and with a mighty butterfly
shove managed to nudge the taxi just
enough to roll us through the visor.

It was downhill after that.
We picked up speed. Lots
of speed.
I thought we were out
of control but . . .

15

There was a brilliant
flash of light and we burst
through a window into a
Landscape with a Greek Temple
and a dazzling sky. And flowers!

"Look how those pink flowers
glisten! I've been craving flowers . . .
so, we must be on the right track!"
Yet Red sped right past the blooms
as we charged back through
the window.

We spun 360 degrees and flipped. . . .

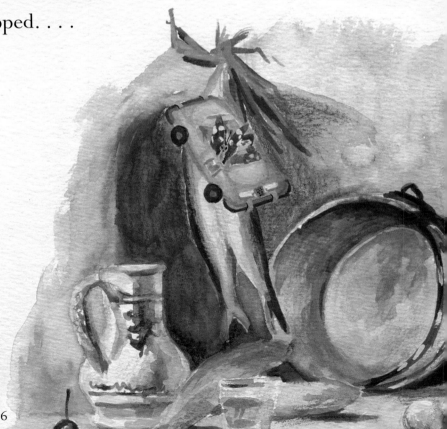

Something seemed fishy. No wonder—
we were hanging with **Herrings**.
We dangled in mid-air, then plunged
toward the mouth of a pitcher.

"Wait! What if there's *water* in there?"
"We're taking e-*VAS*-iv-e action!"
Red called out.
"But, what are we a-*void* . . ."

Before I could
finish we took a
dive, then spun out
of the mouth of an
Amphora, where there
was a party going on.

We dipped and dodged
as we orbited among
the revelers at high
speed. I was getting
dizzy.
"We're traveling in circles,"
I yelled.
"Not to worry. Hold on!"
As if I had a choice.

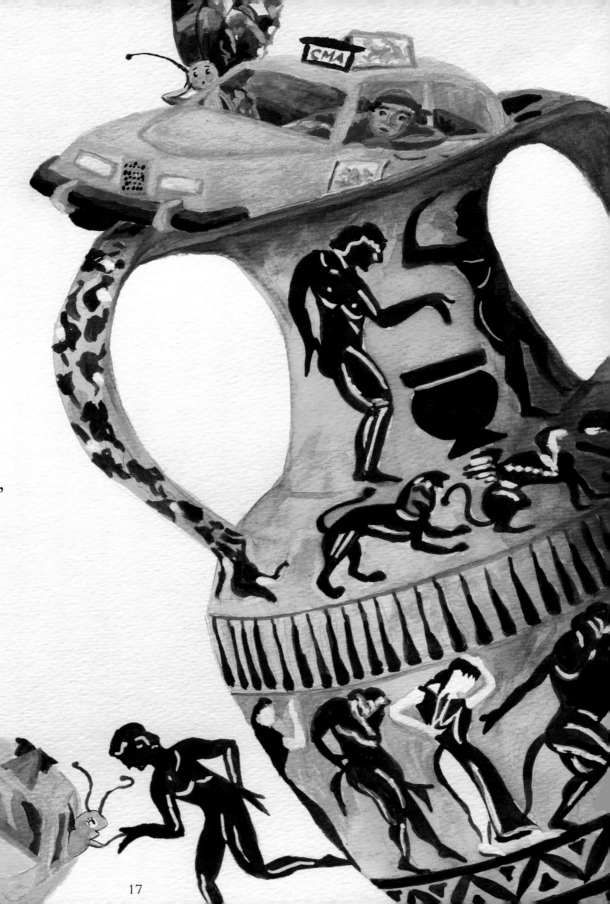

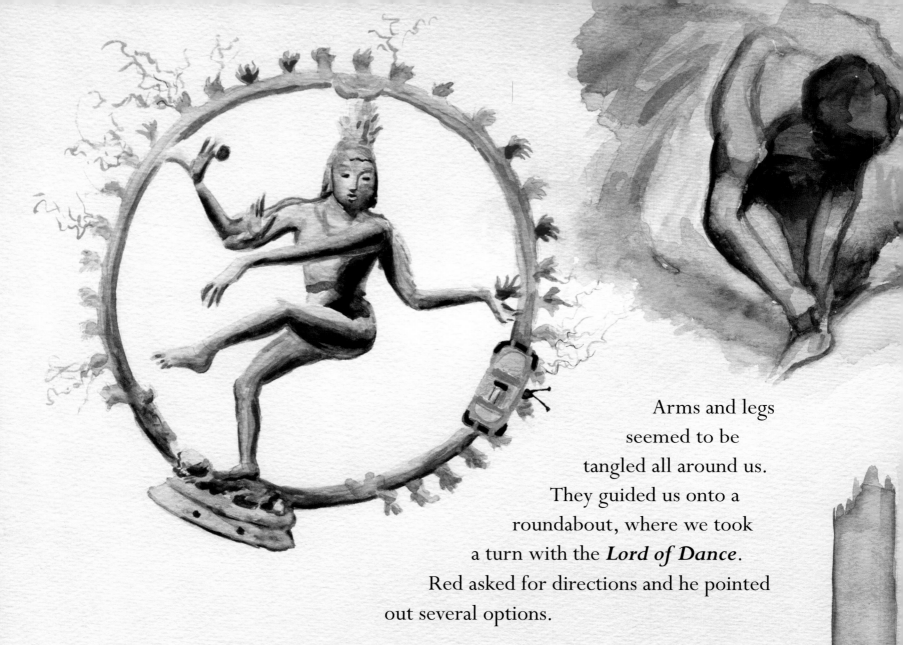

Arms and legs
seemed to be
tangled all around us.
They guided us onto a
roundabout, where we took
a turn with the **Lord of Dance**.
Red asked for directions and he pointed
out several options.

"Those certainly were confusing instructions," Red said.

Suddenly, we stopped circling and sped through the ring. The smoke was so thick
that at first we couldn't see a thing. Turns out it wasn't smoke.

We'd been pushing through the tulle skirts of an entire **Frieze of Dancers**.
We rolled across the canvas, both of us spitting out mouthfuls of the fabric
as it repeatedly smacked us in the face.

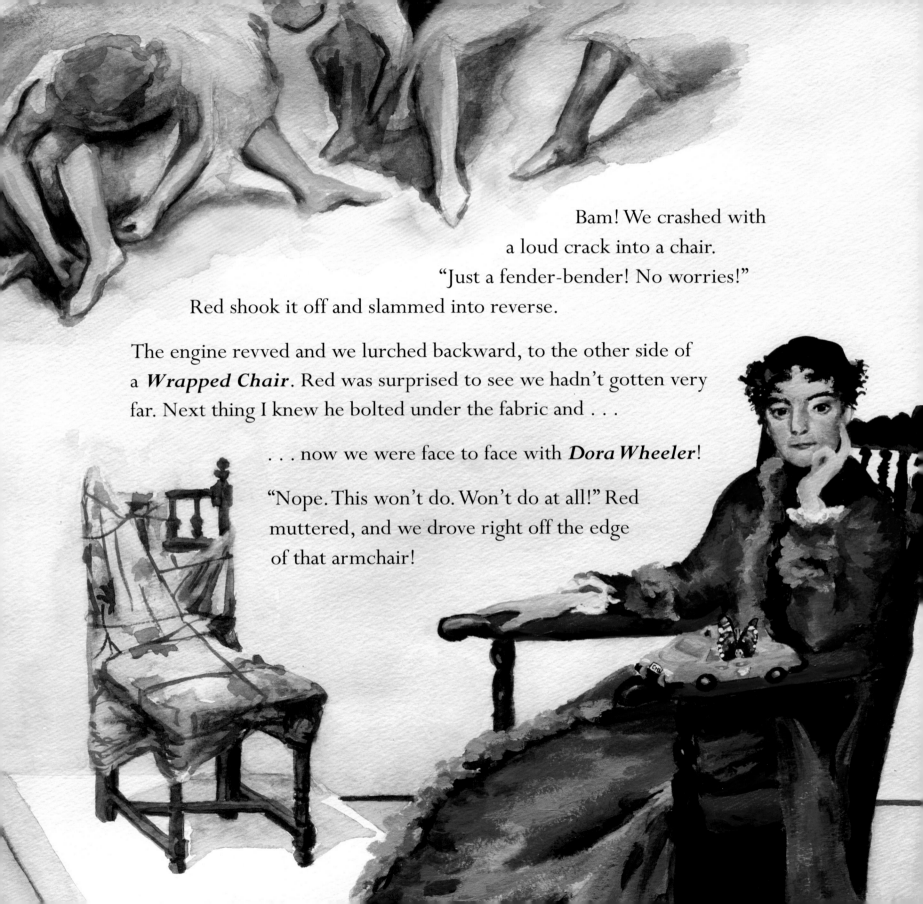

Bam! We crashed with
a loud crack into a chair.
"Just a fender-bender! No worries!"
Red shook it off and slammed into reverse.

The engine revved and we lurched backward, to the other side of
a *Wrapped Chair*. Red was surprised to see we hadn't gotten very
far. Next thing I knew he bolted under the fabric and . . .

. . . now we were face to face with *Dora Wheeler*!

"Nope. This won't do. Won't do at all!" Red
muttered, and we drove right off the edge
of that armchair!

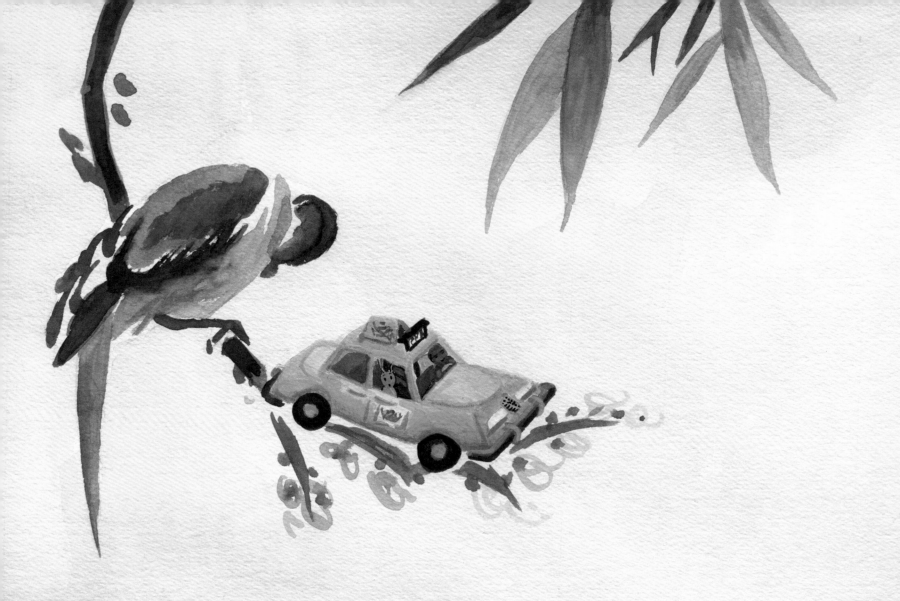

We plummeted through space and landed in **Plum Blossom and Bamboo**.
"Red," I hissed under my breath, "there's a **Bird** on this branch! Birds EAT butterflies!"

"Just be still!" he whispered back. We idled on the branch forever, it seemed.

"Red!" I murmured through clenched butterfly teeth. "I. Want. My. Grandma!"
"I know! I'm sure this bird can show us the way."
"But it just sits there. That creature is like **A Rock That Was Taught It Was a Bird**."
Turns out those were enchanted words, because . . .

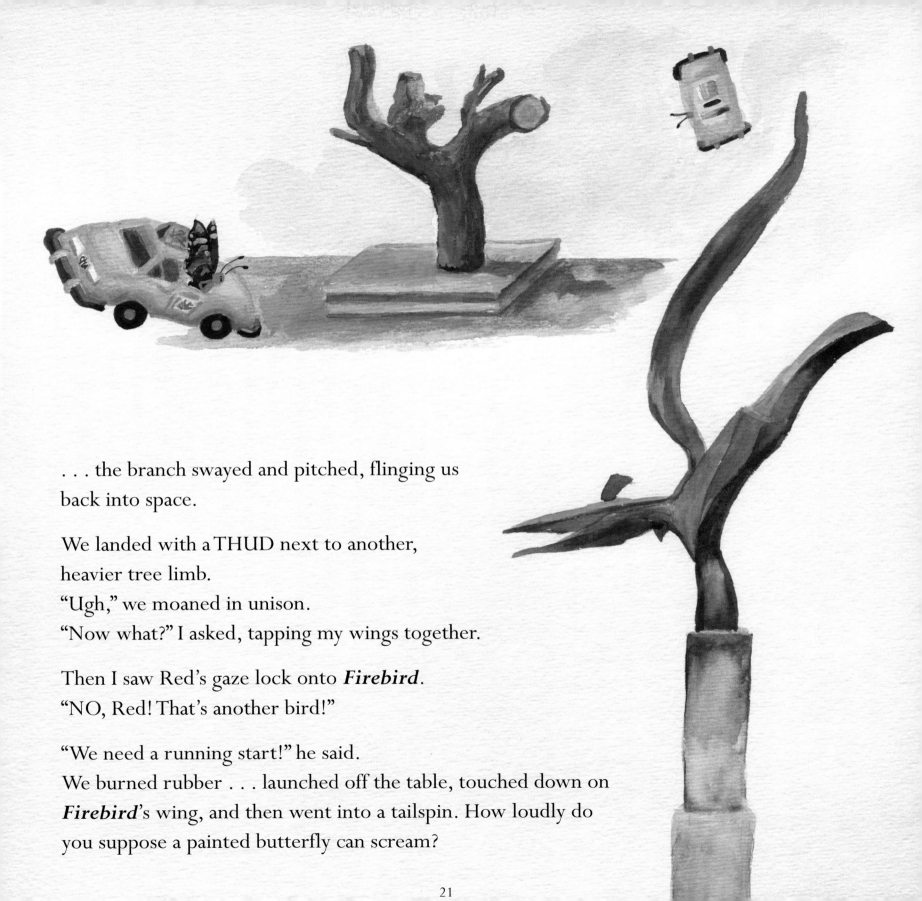

. . . the branch swayed and pitched, flinging us
back into space.

We landed with a THUD next to another,
heavier tree limb.
"Ugh," we moaned in unison.
"Now what?" I asked, tapping my wings together.

Then I saw Red's gaze lock onto *Firebird*.
"NO, Red! That's another bird!"

"We need a running start!" he said.
We burned rubber . . . launched off the table, touched down on
Firebird's wing, and then went into a tailspin. How loudly do
you suppose a painted butterfly can scream?

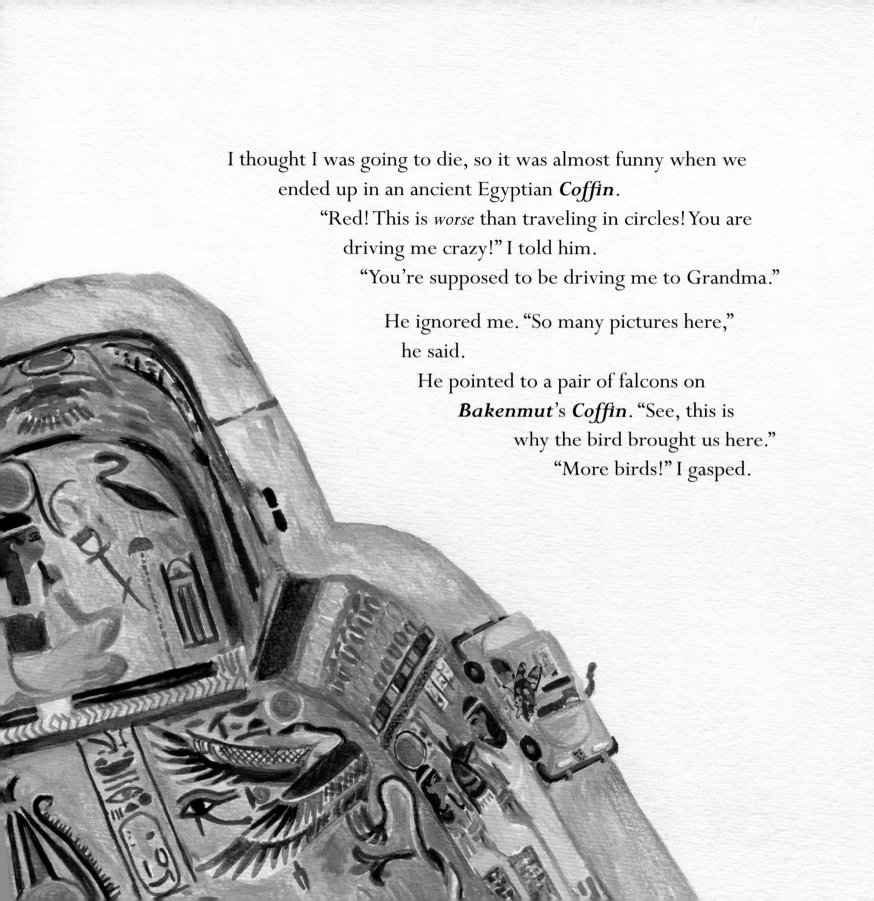

I thought I was going to die, so it was almost funny when we
ended up in an ancient Egyptian **Coffin**.

"Red! This is *worse* than traveling in circles! You are
driving me crazy!" I told him.

"You're supposed to be driving me to Grandma."

He ignored me. "So many pictures here,"
he said.

He pointed to a pair of falcons on
Bakenmut's **Coffin**. "See, this is
why the bird brought us here."

"More birds!" I gasped.

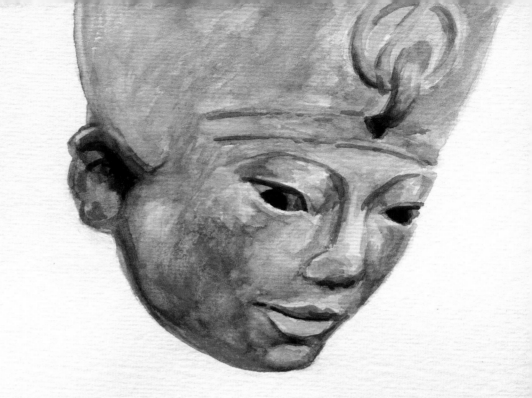

"We can't lose our **Heads** now. We have to make a course correction," he warned.

Then he floored it.

"I need a **Helmet** to ride with this guy!" I thought.

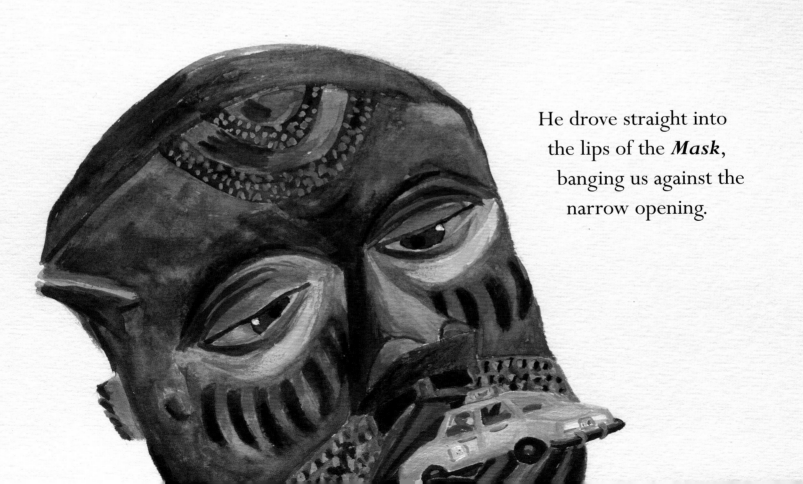

He drove straight into the lips of the **Mask**, banging us against the narrow opening.

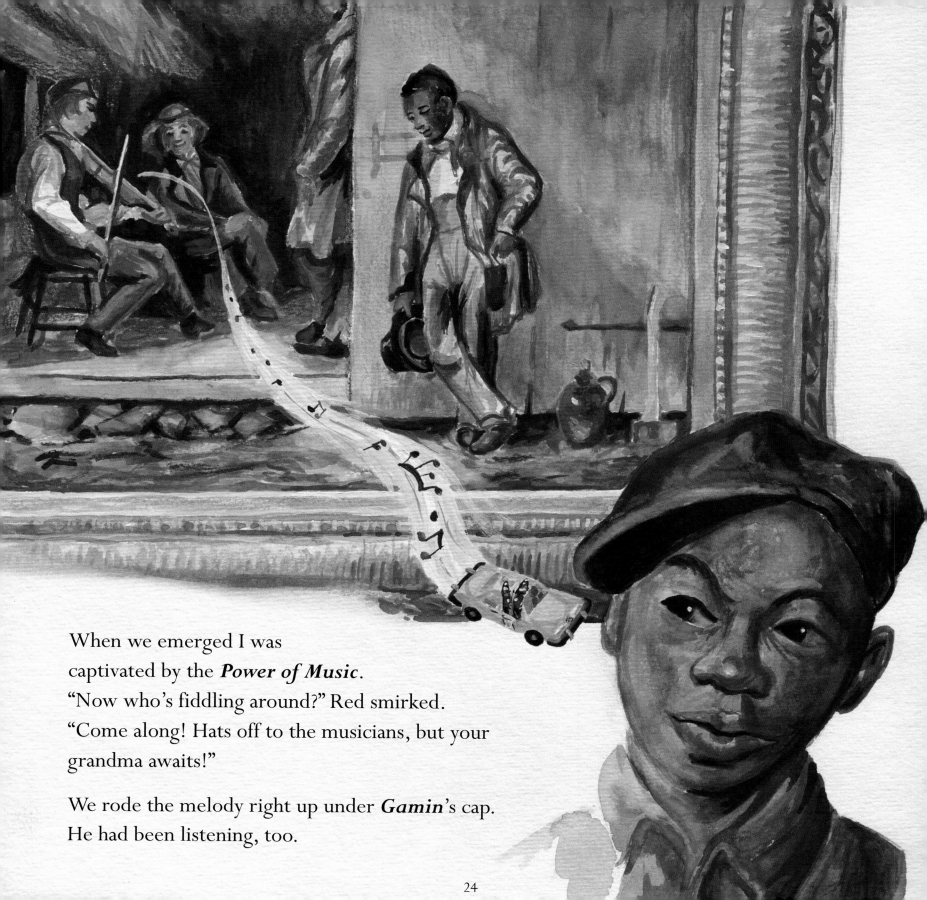

When we emerged I was
captivated by the **Power of Music**.
"Now who's fiddling around?" Red smirked.
"Come along! Hats off to the musicians, but your
grandma awaits!"

We rode the melody right up under **Gamin**'s cap.
He had been listening, too.

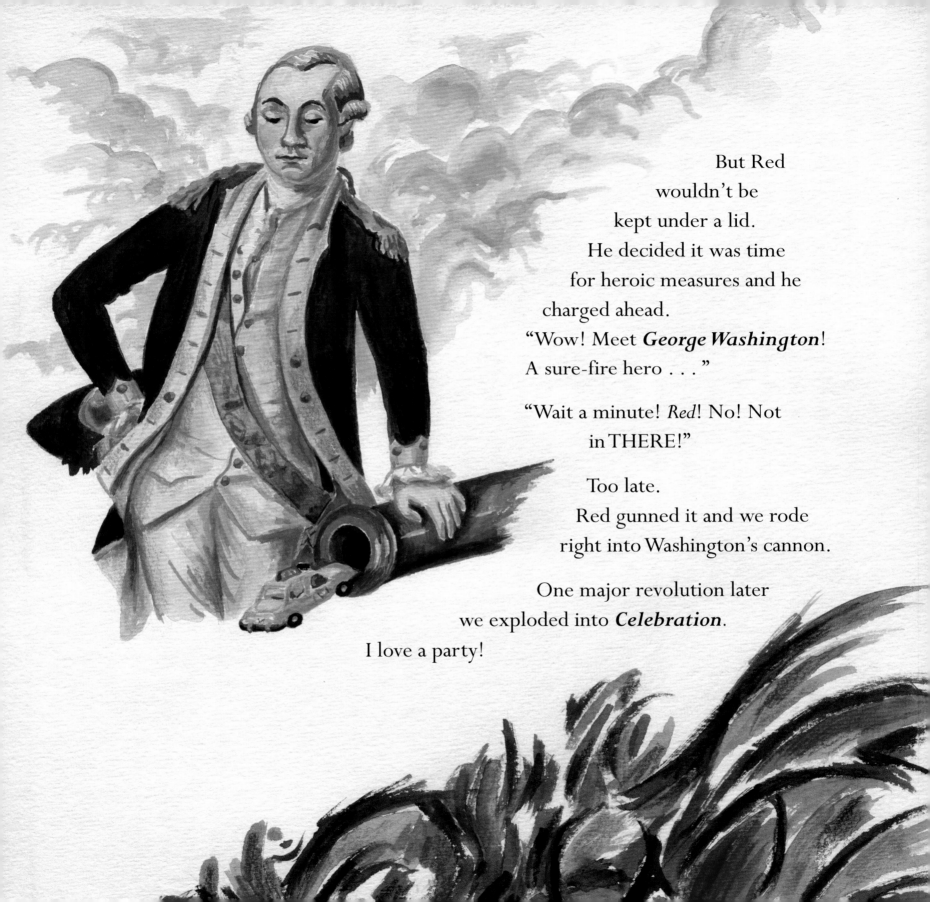

But Red
wouldn't be
kept under a lid.
He decided it was time
for heroic measures and he
charged ahead.
"Wow! Meet *George Washington*!
A sure-fire hero . . ."

"Wait a minute! *Red*! No! Not
in THERE!"

Too late.
Red gunned it and we rode
right into Washington's cannon.

One major revolution later
we exploded into *Celebration*.
I love a party!

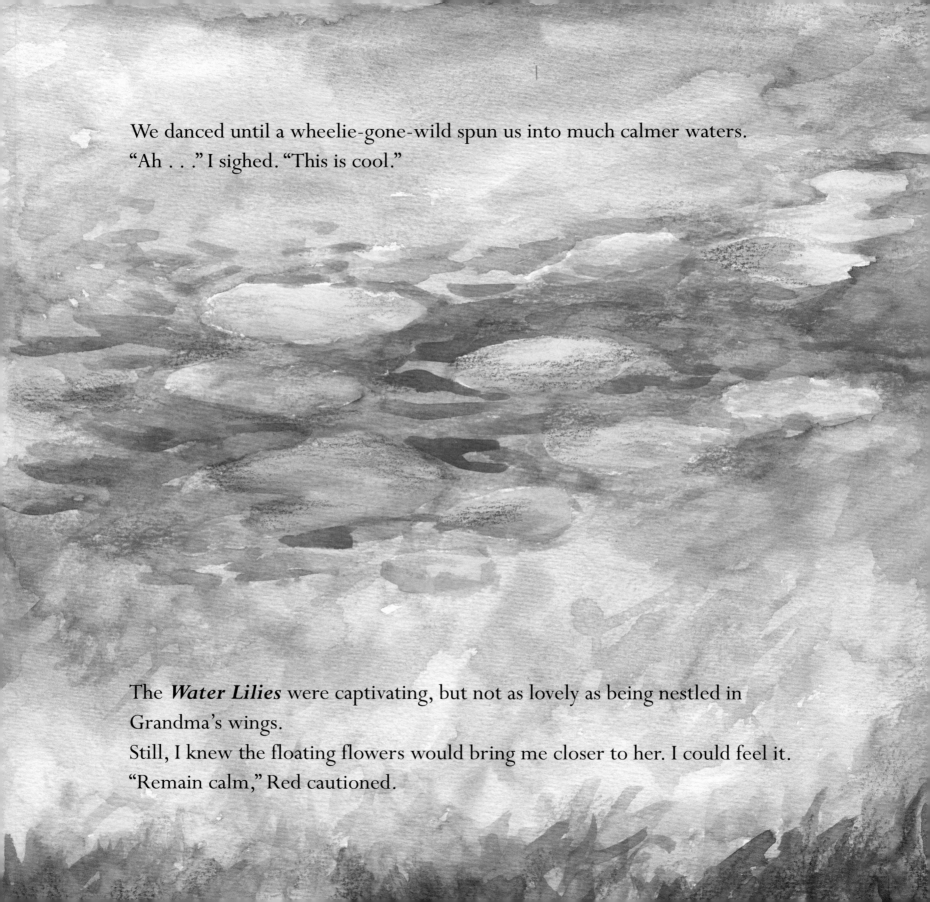

We danced until a wheelie-gone-wild spun us into much calmer waters.
"Ah . . ." I sighed. "This is cool."

The *Water Lilies* were captivating, but not as lovely as being nestled in
Grandma's wings.
Still, I knew the floating flowers would bring me closer to her. I could feel it.
"Remain calm," Red cautioned.

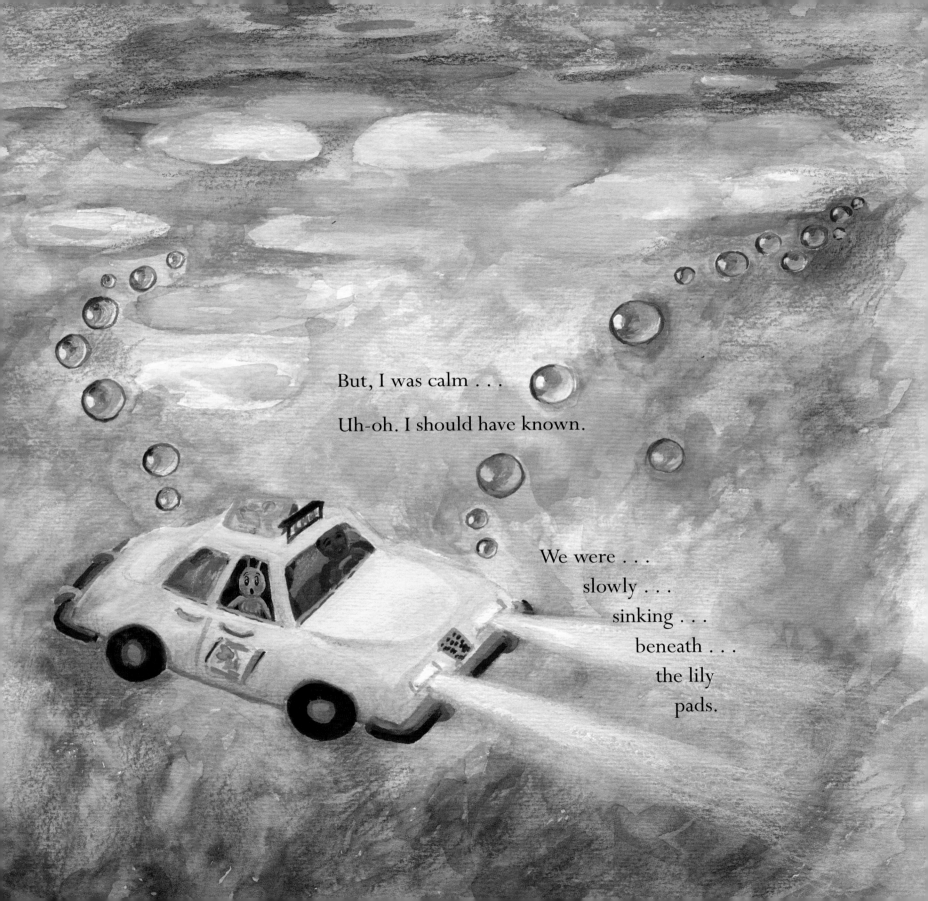

But, I was calm . . .

Uh-oh. I should have known.

We were . . .
slowly . . .
sinking . . .
beneath . . .
the lily
pads.

"GRANDMA!" I cried, as we popped out of a tulip. Her **Flowers in a Glass** were just as I remembered.

"Belle! What a wonderful surprise! What brings you to Cleveland?"
"That's rather a long story . . ."
"Not too long, I hope. I am about to go to Miami. That rumbling is probably my cart."
"Miami! That's where my painting is!"
"My goodness! That's a story I must hear! But for now you'd better nestle in with me, my dear. Clearly, you need a ride to Miami!"

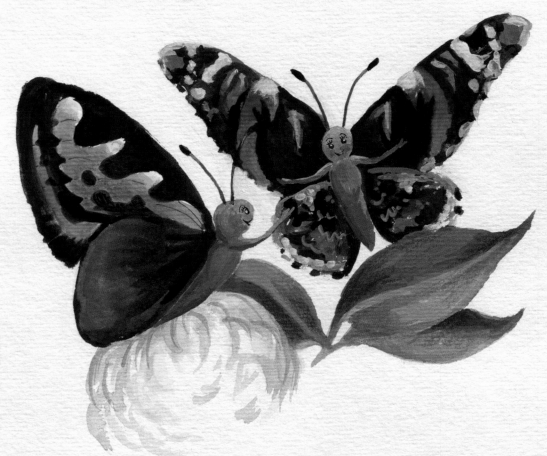

I snuggled deep into Grandma's wings. "Stay still," she said, "and no one will notice there are two of us."

"What about me?"
Oh no. I had forgotten all about Red, now hiding behind our picture frame.
"He's a lousy navigator," I told Grandma.
"He could take weeks getting
back to **Broadway**!"

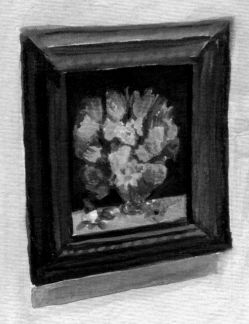
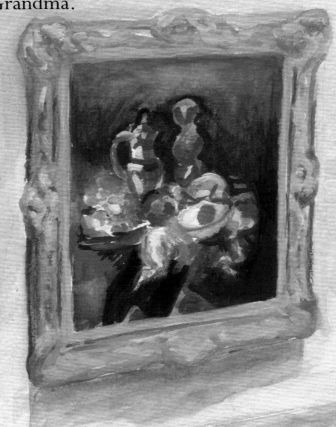

"But Red, my dear, all you have to do is honk three times, fire your spark plugs,
and say: 'Take me to the Big Apple!' as you drive straight into . . . ," Grandma
explained, spying **Gooseberries on a Table**, ". . . that painting!"

Red revved his engines and disappeared into **Gooseberries** just as the cart arrived.
"But Grandma, those aren't big apples!" I said.
"Best I could do. He's a silly goose, so **Gooseberries** should work just as well."

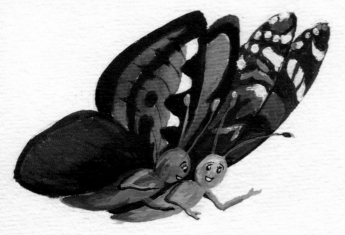

We were well on our way
when Grandma whispered:
"In Miami we'll need to get
you back to your painting.
Good thing we have this long
trip to work out a plan."
"Yeah. And we also have to figure
out how to get Sunny back to Cleveland."
"Sunny? Who's Sunny?"

"I *told* you it was a long story!"

Belle's Postcards from Cleveland

p. 4 *Vase of Flowers*, c. 1660. Jan Davidsz. de Heem (Dutch, 1606–1683/84). Oil on canvas; 69.6 × 56.5 cm. National Gallery of Art, Washington, Andrew W. Mellon Fund, 1961.6.1. Courtesy National Gallery of Art, Washington

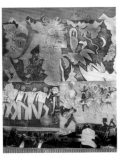

pp. 5–6 *Wrapping It Up at the Lafayette*, 1974. Romare Bearden (American, 1912–1988). Collage, acrylic, and lacquer; 121.9 × 91.5 cm. Mr. and Mrs. William H. Marlatt Fund 1985.41. Art © Romare Bearden Foundation, Inc/Licensed by VAGA, New York, NY

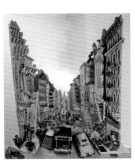

p. 8 *Looking Along Broadway Towards Grace Church*, 1981. Red Grooms (American, b. 1937). Alkyd paint, gatorboard, celastic, wood, wax, foam-core; 180.3 × 161.9 × 73 cm. Gift of Agnes Gund in honor of Edward Henning 1991.27. © Red Grooms/Artists Rights Society (ARS), New York

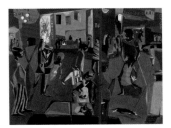

p. 9 *Fulton and Nostrand*, 1958. Jacob Lawrence (American, 1917–2000). Tempera on Masonite; 60.9 × 76.2 cm. Mr. and Mrs. William H. Marlatt Fund 2007.158. © The Jacob and Gwendolyn Lawrence Foundation, Seattle/Artists Rights Society (ARS), New York

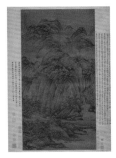

p. 10 *The Woodcutter of Mount Luofu*, 1366. Chen Ruyan (Chinese, c. 1331–before 1371). Hanging scroll, ink on silk; 141 × 76.2 cm. Gift of Mrs. A. Dean Perry 1964.156

p. 11 *Secret Butterfly Heaven*, 2008. Tam Van Tran (American, b. 1966). Acrylic, staples, color pencil on canvas and paper; 253.9 × 233.6 × 129.5 cm. Gift of the Contemporary Art Society and Sundry Art-Contemporary Fund 2009.17. © Tam Van Tran

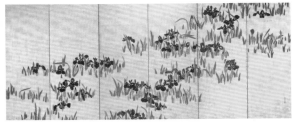

p. 12 *Irises*, 1700s. Watanabe Shiko (Japanese, 1683–1755). Pair of six-fold screens, ink and color on gilded paper; 154 × 334.3 cm. Gift of the Norweb Foundation 1954.603.1

p. 13 *Leaf from a Psalter and Prayerbook: Initial E with Ornamental Border Containing a Seated Satyr and a Bird Eating Grapes*, c. 1524. North Germany, Hildesheim. Ink, tempera, and liquid gold on vellum; 16.6 × 13.5 cm. The Jeanne Miles Blackburn Collection 2006.15.a

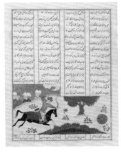

p. 14 *An Archer with a Rolling Target*, from a manuscript of the *Shahnamah* by Firdawsi, late 1400s. Iran, Shiraz, Turkoman, Tabriz period. Opaque watercolor and ink on paper; 22.6 × 16.1 cm. Gift of Heeramaneck Galleries 1942.871

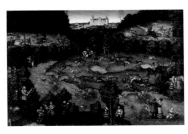

p. 15 *Hunting near Hartenfels Castle*, 1540. Lucas Cranach the Elder (German, 1472–1553). Oil on wood; 116.8 × 170.2 cm. John L. Severance Fund 1958.425

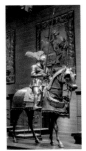

p. 15 *Armor for Man and Horse with Völs-Colonna Arms*, c. 1575. North Italy. Etched steel with gilding. John L. Severance Fund 1964.88

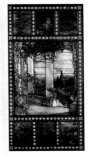

p. 16 *Landscape with a Greek Temple*, c. 1900. Louis Comfort Tiffany (American, 1848–1933). Stained glass; 227.2 × 114.3 cm. Gift of Mrs. Robert M. Fallon 1966.432

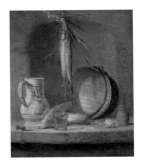

p. 16 *Still Life with Herrings*, c. 1735. Jean Siméon Chardin (French, 1699–1779). Oil on canvas; 41 × 33.6 cm. Leonard C. Hanna Jr. Fund 1974.1

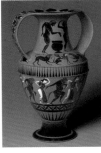

p. 17 *Neck-Amphora*, c. 530–510 BC. Nikosthenes (Greek). Black-figure terracotta; h: 31.1 cm, diam: 16.9 cm. Purchase from the J. H. Wade Fund 1974.10

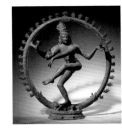

p. 18 *Nataraja, Shiva as the Lord of Dance*, 1000s. South India, Tamil Nadu. Bronze; 111.5 × 101.65 cm. Purchase from the J. H. Wade Fund 1930.331

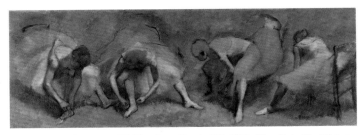

pp. 18–19 *Frieze of Dancers*, c. 1895. Edgar Degas (French, 1834–1917). Oil on fabric; 70 × 200.5 cm. Gift of the Hanna Fund 1946.83

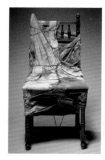

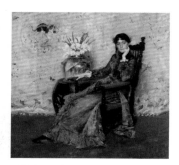

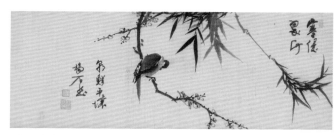

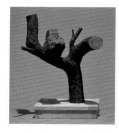

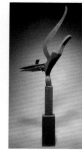

p. 19 *Wrapped Chair*, 1961. Christo (American, b. 1935). Wood, fabric, lacquer paint, and ropes; 90 × 42.5 × 44 cm. Gift of Agnes Gund and Daniel Shapiro 1996.29. © Christo

p. 19 *Portrait of Dora Wheeler*, 1882–83. William Merritt Chase (American, 1849–1916). Oil on canvas; 159 × 165.5 cm. Gift of Mrs. Boudinot Keith in memory of Mr. and Mrs. J. H. Wade 1921.1239

p. 20 *Bird, Plum Blossom, and Bamboo*, 1800s. Yang Ki-hun (Korean, 1843–1898). Hanging scroll, ink on silk; 36.5 × 96.5 cm. John L. Severance Fund 1998.31

p. 21 *A Rock That Was Taught It Was a Bird*, 2010. Beom Kim (Korean, b. 1963). Stone, wood, wooden table, single-channel video on 12-inch flat monitor; video: 1:27:30; table: 73 × 109 × 81 cm. Louis D. Kacalieff M.D. Fund 2010.263. © Kim Beom

p. 21 *Firebird*, 1975. Richard Hunt (American, b. 1935). Welded Corten steel; overall: 243.8 cm. Gift of Mr. and Mrs. Samuel Dorsky 1984.191. © Richard Hunt

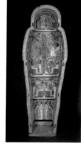

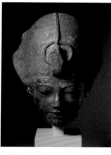

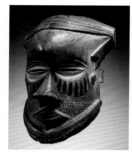

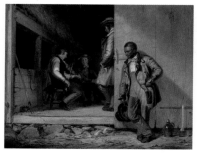

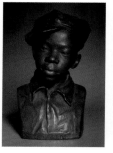

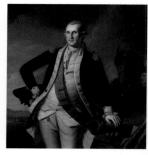

p. 22 *Coffin of Bakenmut*, c. 976–889 BC. Egypt, Thebes. Gessoed and painted sycamore fig; 68 × 208 cm. Gift of the John Huntington Art and Polytechnic Trust 1914.561.a

p. 23 *Head of Amenhotep III Wearing the Blue Crown*, c. 1391–1353 BC. Egypt, Dynasty 18. Granodiorite; 39 × 30.3 × 27.7 cm. Gift of the Hanna Fund 1952.513

p. 23 *Helmet Mask (Bwoom)*, mid–late 1800s. Central Africa, Democratic Republic of the Congo, Kuba people. Wood; 43.3 × 31.2 × 28.3 cm. James Albert Ford Memorial Fund 1935.304

p. 24 *The Power of Music*, 1847. William Sidney Mount (American, 1807–1868). Oil on canvas; 43.4 × 53.5 cm. Leonard C. Hanna Jr. Fund 1991.110

p. 24 *Gamin*, c. 1929–30. Augusta Savage (American, 1892–1962). Hand-painted plaster; 44.5 × 24.2 × 20.4 cm. Purchase from the J. H. Wade Fund 2003.40

p. 25 *George Washington at the Battle of Princeton*, c. 1779. Charles Willson Peale (American, 1741–1827). Oil on canvas; 131 × 121.6 cm. Membership Income Fund 1917.946

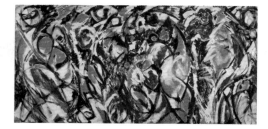

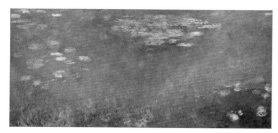

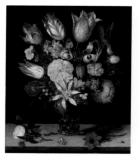

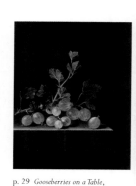

p. 25 *Celebration*, 1960. Lee Krasner (American, 1908–1984). Oil on canvas; 234.3 × 468.6 cm. Purchase from the J. H. Wade Fund 2003.227. © Pollock-Krasner Foundation / Artists Rights Society (ARS), New York

pp. 26–27 *Water Lilies (Agapanthus)*, c. 1915–26. Claude Monet (French, 1840–1926). Oil on canvas; 201.3 × 425.8 cm. John L. Severance Fund 1960.81

p. 29 *Flowers in a Glass*, 1606. Ambrosius Bosschaert the Elder (Dutch, 1573–1621). Oil on copper; 35.6 × 29.3 cm. Gift of Carrie Moss Halle in memory of Salmon Portland Halle 1960.108

p. 29 *Gooseberries on a Table*, 1701. Adriaen Coorte (Dutch, c. 1660–after 1707). Oil on paper mounted on wood; 29.7 × 22.8 cm. Leonard C. Hanna Jr. Fund 1987.32